The Rape of the Lock

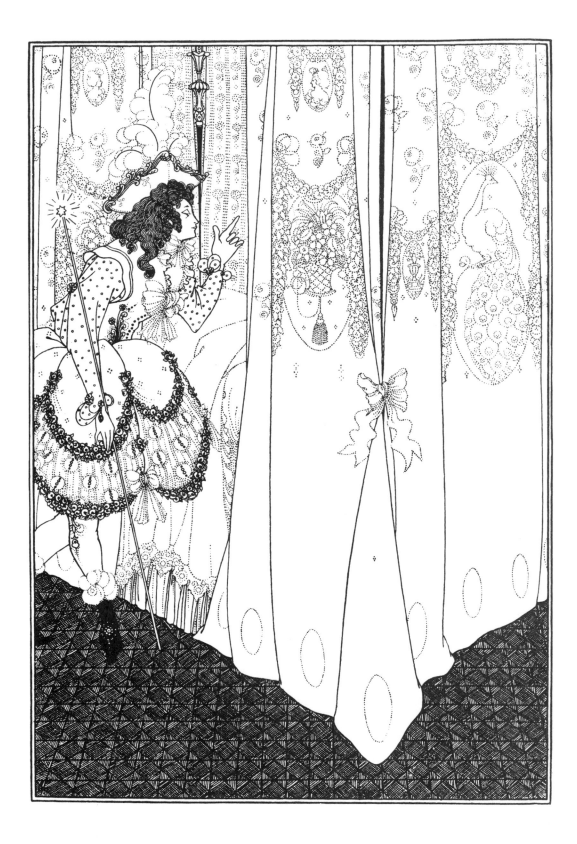

The Rape of the Lock

AN HEROI-COMICAL POEM

IN FIVE CANTOS

WRITTEN BY

ALEXANDER POPE

EMBROIDERED WITH NINE DRAWINGS

BY

AUBREY BEARDSLEY

"Nolueram, Belinda, tuos violare capillos ;
Sed juvat, hoc precibus me tribuisse tuis."—MART.
"A tonso est hoc nomen adepta capillo."—OVID.

DOVER PUBLICATIONS, INC.
NEW YORK

This Dover edition, first published in 1968, is an
unabridged and unaltered republication of the work originally
published by Leonard Smithers in London in 1896.

Standard Book Number: 486-21963-1
Library of Congress Catalog Card Number: 68-25935

Manufactured in the United States of America
Dover Publications, Inc., 31 East 2nd Street, Mineola, N.Y. 11501

TO

EDMUND GOSSE

THIS NEW EDITION

OF

"THE RAPE OF THE LOCK"

THE DRAWINGS

ADVERTISEMENT

THE RAPE OF THE LOCK was first published in the year 1712, by Bernard Lintott, at the sign of the Cross-Keys, between the two Temple Gates, Fleet Street. It was then in two cantos. It was occasioned by a frolic, carried rather beyond the bounds of good breeding, in which Lord Petre cut off a lock of Mrs. Arabella Fermor's hair. The poem was undertaken at Mr. Caryl's request (see Pope's notes), in order to reconcile the two families, this incident having caused a considerable estrangement between them.

The great success of this *jeu d'esprit* induced Pope to extend it from the original two cantos—comprising some 330 lines—to five, by the addition of the "machinery" of Sylphs and Gnomes.

Those readers anxious to be acquainted with the original form of the work will find its extent indicated in the author's notes to the poem, which is here printed in its extended form, with Pope's final revisions.

To MRS. ARABELLA FERMOR

Madam,

IT will be vain to deny that I have some Value for this Piece, since I dedicate it to You. Yet You may bear me Witness, it was intended only to divert a few young Ladies, who have good Sense and good Humour enough, to laugh not only at their Sex's little unguarded Follies, but at their own. But as it was communicated with the Air of a Secret, it soon found its Way into the World. An imperfect Copy having been offered to a Bookseller, You had the Good-Nature for my Sake to consent to the Publication of one more correct: This I was forced to before I had executed half my Design, for the *Machinery* was entirely wanting to compleat it.

The *Machinery*, Madam, is a term invented by the Criticks, to signify that Part which the Deities, Angels, or Daemons, are made to act in a Poem: For the ancient Poets are in one Respect like many modern Ladies: Let an Action be never so trivial in itself, they always make it

appear of the utmost Importance. These Machines I determin'd to raise on a very new and odd Foundation, the *Rosicrucian* Doctrine of Spirits.

I know how disagreeable it is to make use of hard Words before a Lady : but 'tis so much the Concern of a Poet to have his Works understood, and particularly by your Sex, that You must give me leave to explain two or three difficult Terms.

The *Rosicrucians* are a People I must bring You acquainted with. The best Account I know of them is in a French Book called *Le Comte de Gabalis*, which both in its Title and Size is so like a Novel, that many of the Fair Sex have read it for one by Mistake. According to these Gentlemen the four Elements are inhabited by Spirits, which they call *Sylphs, Gnomes, Nymphs*, and *Salamanders*. The *Gnomes*, or Daemons of Earth, delight in Mischief : but the *Sylphs*, whose Habitation is Air, are the best-conditioned Creatures imaginable. For they say, any Mortals may enjoy the most intimate Familiarities with these gentle Spirits, upon a Condition very easy to all true *Adepts*, an inviolate Preservation of Chastity.

As to the following Canto's, all the Passages of them are as Fabulous, as the Vision at the Beginning, or the Trans-

formation at the End; (except the Loss of your Hair, which I always name with Reverence.) The Human Persons are as Fictitious as the Airy ones; and the Character of *Belinda*, as it is now manag'd, resembles You in nothing but in Beauty.

If this Poem had as many Graces as there are in Your Person, or in Your Mind, yet I could never hope it should pass thro' the World half so Uncensured as You have done. But let its Fortune be what it will, mine is happy enough, to have given me this Occasion of assuring You that I am, with the truest Esteem,

> *Madam,*
> *Your most Obedient*
> *Humble Servant,*
> A. POPE.

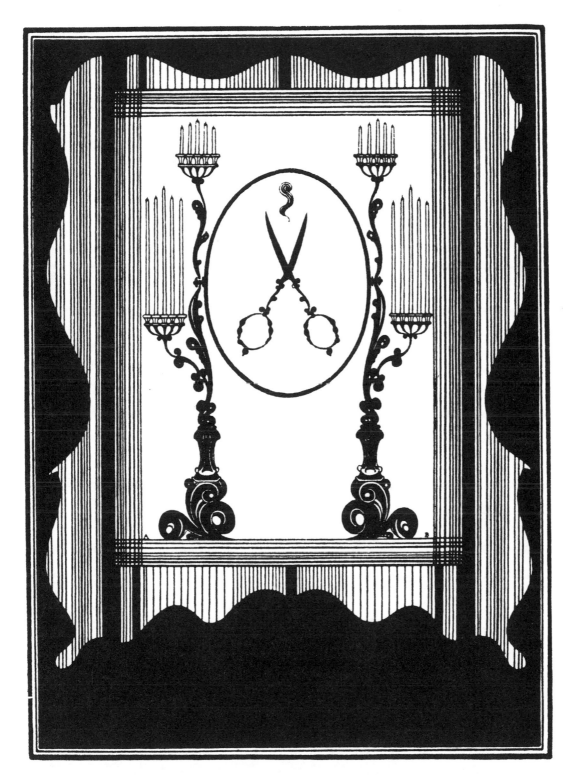

COVER DESIGN OF THE SMITHERS EDITION OF
"THE RAPE OF THE LOCK"

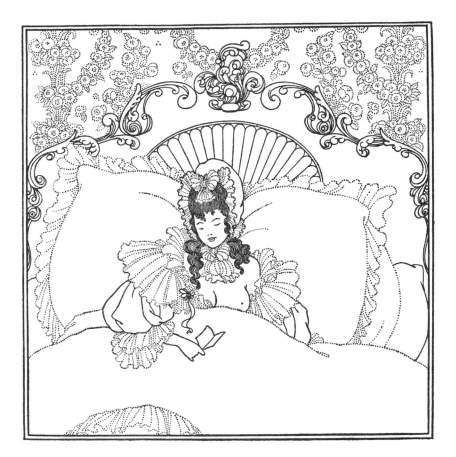

THE RAPE OF THE LOCK

CANTO I

WHAT dire Offence from am'rous Causes springs,
 What mighty Contests rise from trivial Things,
I sing—This verse to CARYL, Muse! is due;
This, ev'n *Belinda* may vouchsafe to view:

Event is not important
—received too high of praise

—love is real

Slight is the Subject, but not so the Praise, 5
If She inspire, and He approve, my Lays.

 Say what strange Motive, Goddess ! cou'd compel
A well-bred *Lord* t' assault a gentle *Belle ?*
Oh say what stranger Cause, yet unexplor'd,
Cou'd make a gentle *Belle* reject a *Lord ?* 10
In tasks so bold, can little Men engage,
And in soft Bosoms, dwell such mighty Rage ?

 Sol through white Curtains shot a tim'rous Ray,
And ope'd those Eyes that must eclipse the Day :
Now Lap-dogs give themselves the rouzing Shake, 15
And sleepless Lovers, just at Twelve, awake :
Thrice rung the Bell, the Slipper knock'd the Ground,
And the press'd Watch return'd a silver sound,
Belinda still her downy Pillow prest,
Her guardian *Sylph* prolong'd the balmy rest. 20
'Twas he had summon'd to her silent Bed
The Morning Dream that hover'd o'er her Head.
A Youth more glitt'ring than a *Birth-night Beau*
(That ev'n in slumber caus'd her Cheek to glow)
Seem'd to her Ear his winning Lips to lay, 25
And thus in Whispers said, or seemed to say.

 Fairest of Mortals, thou distinguish'd Care

Of thousand bright Inhabitants of Air!
If e'er one Vision touch'd thy infant Thought,
Of all the Nurse and all the Priest have taught, 30
Of airy Elves by Moonlight Shadows seen,
The silver Token, and the Circled Green,
Or Virgins visited by Angel-pow'rs
With Golden Crowns and Wreaths of heav'nly Flow'rs;
Hear and believe! thy own Importance know, 35
Nor bound thy narrow Views to things below.
Some secret Truths, from Learned Pride conceal'd,
To Maids alone and Children are reveal'd:
What tho' no Credit doubting Wits may give?
The Fair and Innocent shall still believe. 40
Know then, unnumber'd Spirits round thee fly,
The light *Militia* of the lower sky:
These, tho' unseen, are ever on the Wing,
Hang o'er the *Box*, and hover round the *Ring*.
Think what an Equipage thou hast in Air, 45
And view with scorn *Two Pages* and a *Chair*.
As now your own, our Beings were of old,
And once inclos'd in Woman's beauteous Mold;
Thence, by a soft Transition, we repair
From earthly Vehicles to these of Air. 50
Think not, when Woman's transient Breath is fled,
That all her Vanities at once are dead.

Succeeding Vanities she still regards,

And tho' she plays no more, o'erlooks the Cards.

Her Joy in gilded Chariots, when alive, 55

And love of *Ombre*, after Death survive.

For when the Fair in all their Pride expire,

To their first Elements the Souls retire :

The Sprites of fiery Termagants in Flame

Mount up, and take a *Salamander's* name. 60

Soft yielding Minds to Water glide away,

And sip, with *Nymphs*, their elemental Tea.

The graver Prude sinks downward to a *Gnome*,

In search of Mischief still on Earth to roam.

The light Coquettes in *Sylphs* aloft repair, 65

And sport and flutter in the Fields of Air.

 Know further yet ; Whoever fair and chaste

Rejects Mankind, is by some *Sylph* embrac'd :

For Spirits, freed from mortal Laws, with ease

Assume what Sexes and what Shapes they please. 70

What guards the Purity of melting Maids,

In Courtly Balls, and Midnight Masquerades,

Safe from the treach'rous Friend, the daring Spark,

The Glance by Day, the Whisper in the Dark ;

When kind Occasion prompts their warm Desires, 75

When Music softens, and when Dancing fires ?

'Tis but their *Sylph*, the wise Celestials know,
Tho' *Honour* is the Word with Men below.

Some Nymphs there are, too conscious of their Face,
For Life predestin'd to the *Gnomes*' Embrace. 80
Who swell their Prospects and exalt their Pride,
When Offers are disdain'd, and Love deny'd.
Then gay Ideas crowd the vacant Brain,
While Peers and Dukes, and all their sweeping Train,
And Garters, Stars, and Coronets appear, 85
And in soft sounds, *Your Grace* salutes their Ear.
'Tis these that early taint the Female Soul,
Instruct the eyes of young *Coquettes* to roll,
Teach Infant Cheeks a bidden Blush to know,
And little Hearts to flutter at a *Beau*. 90

Oft when the World imagine Women stray,
The *Sylphs* through Mystic mazes guide their Way.
Thro' all the giddy Circle they pursue,
And old Impertinence expel by new.
What tender Maid but must a Victim fall 95
To one Man's Treat, but for another's Ball?
When *Florio* speaks, what Virgin could withstand,
If gentle *Damon* did not squeeze her Hand?
With varying Vanities, from ev'ry Part,

They shift the moving Toyshop of their Heart ; 100
Where Wigs with Wigs, with Sword-knots Sword-knots
 strive,
Beaux banish Beaux, and Coaches Coaches drive.
This erring Mortals Levity may call,
Oh blind to Truth ! the *Sylphs* contrive it all.

Of these am I, who thy Protection claim, 105
A watchful Sprite, and *Ariel* is my Name.
Late, as I rang'd the crystal Wilds of Air,
In the clear Mirror of thy ruling *Star*
I saw, alas ! some dread Event impend,
Ere to the Main this morning's Sun descend, 110
But Heav'n reveals not what, or how, or where :
Warn'd by thy *Sylph*, oh pious Maid beware !
This to disclose is all thy Guardian can.
Beware of all, but most beware of Man !

He said : when *Shock*, who thought she slept too long,
Leap'd up, and wak'd his Mistress with his Tongue. 116
'Twas then, *Belinda !* if Report say true,
Thy Eyes first open'd on a *Billet-doux ;*
Wounds, Charms, and *Ardors,* were no sooner read,
But all the Vision vanish'd from thy Head. 120

And now, unveil'd, the *Toilet* stands display'd,
Each Silver Vase in mystic Order laid.

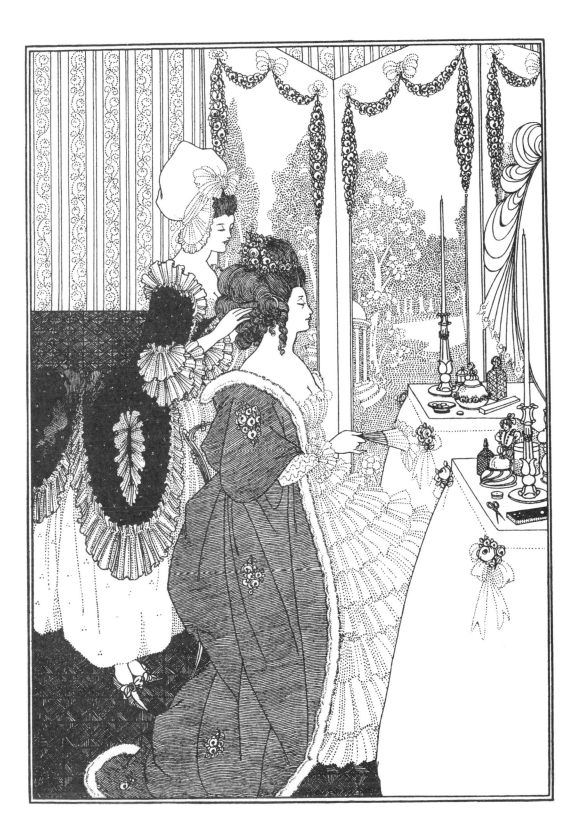

(handwritten, top right: Dressing scene)

First, rob'd in White, the Nymph intent adores *(handwritten: a woman's Vanity)*
With Head uncover'd, the *Cosmetic* Pow'rs. 125 *(handwritten: over-the-top)*
A heav'nly Image in the Glass appears,
To that she bends, to that her Eyes she rears; *(handwritten: Goddess— image in mirror.)*
Th' inferior Priestess, at her Altar's side, *(handwritten: mockery)* *(handwritten: Priestess— maid)*
Trembling, begins the sacred Rites of Pride.
Unnumber'd Treasures ope at once, and here 130 *(handwritten: gifts from all over?)*
The various Off'rings of the World appear;
From each she nicely culls with curious Toil,
And decks the Goddess with the glitt'ring Spoil.
This Casket *India's* glowing Gems unlocks,
And all *Arabia* breathes from yonder Box.
The Tortoise here and Elephant unite, 135
Transform'd to *Combs*, the speckled and the white.
Here Files of Pins extend their shining Rows, *(handwritten: A love letter)*
Puffs, Powders, Patches, Bibles, Billet-doux.
Now awful Beauty puts on all its Arms;
The Fair each moment rises in her Charms, 140
Repairs her Smiles, awakens ev'ry Grace,
And calls forth all the Wonders of her Face;
Sees by Degrees a purer Blush arise,
And keener Lightnings quicken in her Eyes.
The busy *Sylphs* surround their darling Care; 145
These set the Head, and those divide the Hair,
Some fold the Sleeve, whilst others plait the Gown;
And *Betty*'s prais'd for labours not her own, *(handwritten: Sylphs do all work — She is so beautiful has army)*

(handwritten left margin, vertical: Aristeia - arming scene)

CANTO II

NOT with more Glories, in th' Ethereal Plain,
The Sun first rises o'er the purpled Main,
Than issuing forth, the Rival of his Beams
Launch'd on the Bosom of the Silver *Thames*.
Fair Nymphs, and well-drest Youths around her shone, 5
But ev'ry Eye was fix'd on her alone.
On her white Breast a sparkling *Cross* she wore,
Which *Jews* might kiss, and Infidels adore.
Her lively Looks a sprightly Mind disclose,
Quick as her Eyes, and as unfix'd as those : 10
Favours to none, to all she Smiles extends,
Oft she rejects, but never once offends.
Bright as the Sun, her Eyes the Gazers strike,
And, like the Sun, they shine on all alike.
Yet graceful Ease, and Sweetness void of Pride, 15
Might hide her Faults, if *Belles* had Faults to hide :
If to her share some Female Errors fall,
Look on her Face, and you'll forget 'em all.

This Nymph, to the Destruction of Mankind,

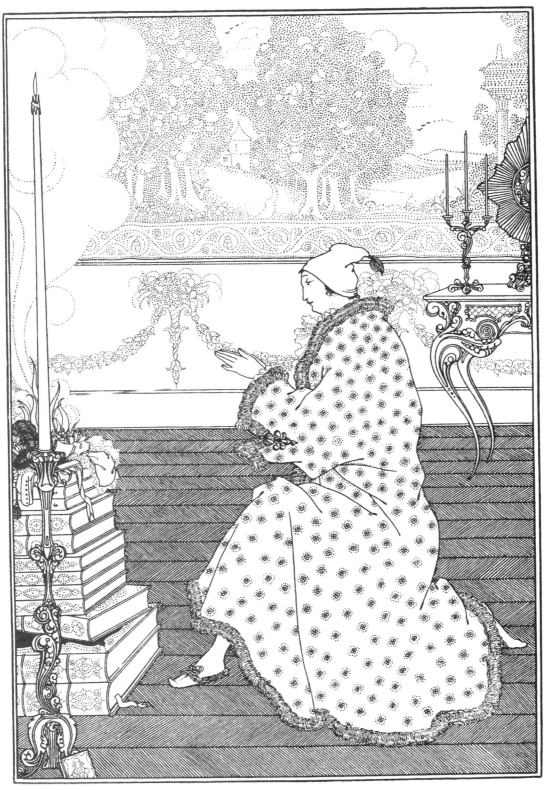

Nourish'd two Locks which graceful hung behind 20
In equal Curls, and well conspir'd to deck
With shining Ringlets the smooth Iv'ry Neck.
Love in these Labyrinths his Slaves detains,
And mighty Hearts are held in slender Chains.
With hairy sprindges we the Birds betray, 25
Slight lines of Hair surprise the Finny Prey,
Fair Tresses Man's Imperial Race insnare,
And Beauty draws us with a single Hair.

Th' Advent'rous *Baron* the bright Locks admir'd,
He saw, he wish'd, and to the Prize aspir'd: 30
Resolv'd to win, he meditates the way,
By Force to ravish, or by Fraud betray;
For when Success a Lover's Toil attends,
Few ask, if Fraud or Force attain'd his Ends.

For this, ere *Phœbus* rose, he had implor'd 35
Propitious Heav'n, and ev'ry Pow'r ador'd,
But chiefly *Love*—to *Love* an Altar built,
Of twelve vast *French* Romances, neatly gilt.
There lay three Garters, half a Pair of Gloves,
And all the Trophies of his former Loves. 40
With tender *Billet-doux* he lights the Pyre,
And breathes three am'rous Sighs to raise the Fire.

Then prostrate falls, and begs with ardent Eyes
Soon to obtain, and long possess the Prize:
The Pow'rs gave Ear, and granted half his Pray'r, 45
The rest, the Winds dispers'd in empty Air.

 But now secure the painted Vessel glides,
The Sun-beams trembling on the floating Tydes,
While melting Musick steals upon the Sky,
And soften'd Sounds along the Waters die. 50
Smooth flow the Waves, the Zephyrs gently play,
Belinda smil'd, and all the World was gay.
All but the *Sylph*—With careful Thoughts opprest,
Th' impending Woe sat heavy on his Breast.
He summons straight his Denizens of Air; 55
The lucid Squadrons round the Sails repair:
Soft o'er the Shrouds Aerial Whispers breath,
That seem'd but Zephyrs to the Train beneath.
Some to the Sun their Insect-Wings unfold,
Waft on the Breeze, or sink in Clouds of Gold. 60
Transparent Forms, too fine for mortal Sight,
Their fluid Bodies half dissolv'd in Light.
Loose to the Wind their airy Garments flew,
Thin glitt'ring Textures of the filmy Dew;
Dipt in the richest Tincture of the Skies, 65
Where Light disports in ever-mingling Dies,

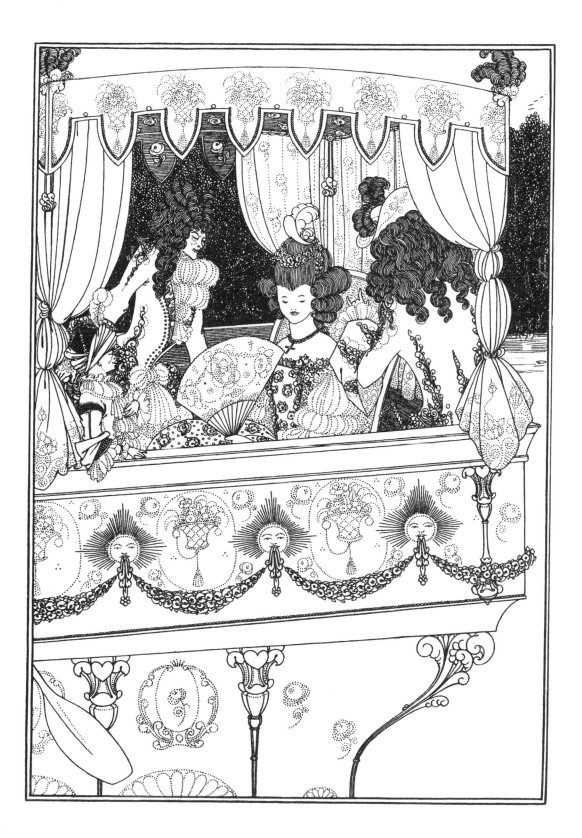

While ev'ry Beam new transient Colours flings,
Colours that change whene'er they wave their Wings.
Amid the Circle, on the gilded mast,
Superiour by the Head, was *Ariel* plac'd ; 70
His Purple Pinions op'ning to the Sun,
He rais'd his Azure Wand, and thus begun.

 Ye *Sylphs* and *Sylphids*, to your Chief give ear,
Fays, Fairies, Genii, Elves, and *Daemons* hear !
Ye know the Spheres and various Tasks assign'd 75
By Laws Eternal to th' Aerial Kind.
Some in the Fields of purest *Aether* play,
And bask and whiten in the Blaze of Day.
Some guide the Course of wand'ring Orbs on high,
On roll the Planets through the boundless Sky. 80
Some less refin'd, beneath the Moon's pale Light
Pursue the Stars that shoot athwart the Night ;
Or suck the Mists in grosser Air below,
Or dip their Pinions in the painted Bow,
Or brew fierce Tempests on the wintry Main, 85
Or o'er the Glebe distil the kindly Rain.
Others on Earth o'er human Race preside,
Watch all their Ways, and all their Actions guide :
Of these the Chief the Care of Nations own,
And guard with Arms Divine the *British Throne*. 90

Our humbler Province is to tend the Fair,
Not a less pleasing, tho' less glorious Care.
To save the Powder from too rude a Gale,
Nor let th' imprison'd Essences exhale;
To draw fresh Colours from the vernal Flow'rs, 95
To steal from Rainbows ere they drop in Show'rs
A brighter Wash; to curl their waving Hairs,
Assist their Blushes, and inspire their Airs;
Nay oft, in Dreams, Invention we bestow,
To change a *Flounce*, or add a *Furbelo!* 100

This Day, black Omens threat the brightest Fair
That e'er deserv'd a watchful Spirit's Care;
Some dire Disaster, or by Force, or Slight,
But what, or where, the Fates have wrapt in Night.
Whether the Nymph shall break *Diana's* law, 105
Or some frail *China* jar receive a Flaw,
Or stain her Honour, or her new Brocade,
Forget her Pray'rs, or miss a Masquerade,
Or lose her Heart, or Necklace, at a Ball;
Or whether Heav'n has doom'd that *Shock* must fall. 110
Haste then ye Spirits! to your Charge repair;
The flutt'ring Fan be *Zephyretta's* Care;
The Drops to thee, *Brillante*, we consign;
And, *Momentilla*, let the Watch be thine;

Do thou, *Crispissa*, tend her fav'rite Lock ; 115
Ariel himself shall be the guard of *Shock*.

lapdog

 To Fifty chosen *Sylphs*, of special Note,
We trust th' important Charge, the *Petticoat :*
Oft have we known that sev'nfold Fence to fail,
Tho' stiff with Hoops, and arm'd with Ribs of Whale. 120
Form a strong Line about the Silver Bound,
And guard the wide Circumference around.

 Whatever Spirit, careless of his Charge,
His Post neglects, or leave the Fair at large,
Shall feel sharp Vengeance soon o'ertake his Sins, 125
Be stop'd in *Vials*, or transfixt with *Pins ;*
Or plung'd in Lakes of bitter *Washes* lie,
Or wedg'd whole Ages in a *Bodkin's* Eye :

Sylphs small, insignificant

Gums and *Pomatums* shall his Flight restrain,
While clog'd he beats his silken Wings in vain ; 130
Or Alom-*Stypticks* with contracting Pow'r
Shrink his thin Essence like a rivell'd Flower.
Or, as *Ixion* fix'd, the Wretch shall feel
The giddy Motion of the whirling Mill,
Midst Fumes of burning Chocolate shall glow, 135
And tremble at the Sea that froaths below !

Hortatory Rhetoric: motivational
speech - irony in insignificance

He spoke; the Spirits from the Sails descend;
Some, Orb in Orb, around the Nymph extend,
Some thrid the mazy Ringlets of her Hair,
Some hang upon the Pendants of her Ear; 140
With beating Hearts the dire Event they wait,
Anxious, and trembling for the Birth of Fate.

CANTO III

CLOSE by those Meads for ever crown'd with Flow'rs,
Where *Thames* with Pride surveys his rising Tow'rs,
There stands a Structure of Majestic Fame,
Which from the neighb'ring *Hampton* takes its Name.
Here *Britain's* Statesmen oft the Fall foredoom 5
Of foreign Tyrants, and of Nymphs at home;
Here Thou, great *Anna!* whom three Realms obey,
Dost sometimes Counsel take—and sometimes *Tea.*

 Hither the Heroes and the Nymphs resort,
To taste awhile the Pleasures of a Court; 10
In various Talk th' instructive Hours they past,
Who gave a *Ball*, or paid the *Visit* last:
One speaks the Glory of the *British Queen*,
And one describes a charming *Indian Screen*;
A third interprets Motions, Looks, and Eyes; 15
At every Word a Reputation dies.
Snuff, or the *Fan*, supply each Pause of Chat,
With singing, laughing, ogling, *and all that.*

Mean while, declining from the Noon of Day,
The Sun obliquely shoots his burning Ray; 20
The hungry Judges soon the Sentence sign,
And Wretches hang that Jury-men may Dine;
The Merchant from th' *Exchange* returns in Peace,
And the long Labours of the Toilet cease.
Belinda now, whom Thirst of Fame invites, 25
Burns to encounter two adventrous Knights,
At *Ombre* singly to decide their Doom;
And swells her Breast with Conquests yet to come.
Straight the three Bands prepare in Arms to join,
Each Band the number of the Sacred Nine. 30
Soon as she spreads her Hand, th' Aerial Guard
Descend, and sit on each important Card:
First *Ariel* perch'd upon a *Matadore*,
Then each, according to the Rank they bore;
For *Sylphs*, yet mindful of their ancient Race, 35
Are, as when women, wond'rous fond of Place.

 Behold, four *Kings*, in Majesty rever'd,
With hoary Whiskers and a forky Beard;
And four fair *Queens* whose Hands sustain a Flow'r,
Th' expressive Emblem of their softer Pow'r; 40
Four *Knaves* in Garbs succinct, a trusty Band;
Caps on their heads, and Halberds in their hand;

And particolour'd Troops, a shining Train,
Draw forth to combat on the Velvet Plain.

The skilful Nymph reviews her Force with Care; 45
Let Spades be Trumps! she said, and Trumps they were.

Now move to War her Sable *Matadores*,
In show like Leaders of the swarthy *Moors*.
Spadillio first, unconquerable Lord!
Let off two captive Trumps, and swept the Board. 50
As many more *Manillio* forc'd to yield,
And march'd a Victor from the verdant Field.
Him *Basto* follow'd, but his Fate more hard
Gain'd but one Trump and one *Plebeian* card.
With his broad Sabre next, a Chief in Years, 55
The hoary Majesty of *Spades* appears;
Puts forth one manly Leg, to sight reveal'd,
The rest, his many-colour'd Robe conceal'd.
The Rebel-*Knave*, that dares his Prince engage,
Proves the just Victim of his Royal Rage. 60
Ev'n mighty *Pam*, that Kings and Queens o'erthrew,
And mow'd down Armies in the Fights of *Lu*,
Sad Chance of War! now, destitute of Aid,
Falls undistinguish'd by the Victor *Spade!*

Thus far both Armies to *Belinda* yield;

Now to the *Baron* Fate inclines the Field.
His warlike *Amazon* her Host invades,
Th' Imperial Consort of the Crown of *Spades*.
The *Club's* black Tyrant first her Victim dy'd,
Spite of his haughty Mien, and barb'rous Pride : 70
What boots the Regal Circle on his Head,
His Giant Limbs, in State unwieldy spread ;
That long behind he trails his pompous Robe,
And of all Monarchs only grasps the Globe ?

The *Baron* now his *Diamonds* pours apace ; 75
Th' embroider'd *King* who shows but half his Face,
And his refulgent *Queen*, with Pow'rs combin'd,
Of broken Troops an easy Conquest find.
Clubs, *Diamonds*, *Hearts*, in wild Disorder seen,
With Throngs promiscuous strew the level Green. 80
Thus when dispers'd a routed Army runs,
Of *Asia's* Troops, and *Afric's* Sable Sons,
With like Confusion different Nations fly,
In various Habits, and of various Dye,
The pierc'd Battalions dis-united fall, 85
In Heaps on Heaps ; one Fate o'erwhelms them all.

The *Knave* of *Diamonds* tries his wily Arts,
And wins (oh shameful Chance !) the *Queen* of *Hearts*.

At this, the Blood the Virgin's Cheek forsook,
A livid Paleness spreads o'er all her Look; 90
She sees, and trembles at th' approaching Ill,
Just in the Jaws of Ruin, and *Codille*.
And now (as oft in some distemper'd State)
On one nice *Trick* depends the gen'ral Fate,
An *Ace* of Hearts steps forth: The *King* unseen 95
Lurk'd in her Hand, and mourn'd his captive *Queen*.
He springs to Vengeance with an eager Pace,
And falls like Thunder on the prostrate *Ace*.
The Nymph exulting fills with Shouts the Sky;
The Walls, the Woods, and long Canals reply. 100

Oh thoughtless Mortals! ever blind to Fate,
Too soon dejected, and too soon elate!
Sudden these Honours shall be snatch'd away,
And curs'd for ever this Victorious Day.

For lo! the Board with Cups and Spoons is crown'd, 105
The Berries crackle, and the Mill turns round;
On shining Altars of *Japan* they raise
The silver Lamp, and fiery Spirits blaze:
From silver Spouts the grateful Liquors glide,
And *China's* earth receives the smoking Tyde. 110
At once they gratify their Scent and Taste,

While frequent Cups prolong the rich Repast.
Strait hover round the Fair her Airy Band;
Some, as she sipp'd, the fuming Liquor fann'd,
Some o'er her Lap their careful Plumes display'd, 115
Trembling, and conscious of the rich Brocade.
Coffee (which makes the Politician wise,
And see through all things with his half-shut Eyes)
Sent up in Vapours to the *Baron's* Brain
New Stratagems, the radiant Lock to gain. 120
Ah cease rash Youth! desist e'er 'tis too late,
Fear the just Gods, and think of *Scylla's* Fate!
Chang'd to a Bird, and sent to flit in Air,
She dearly pays for *Nisus'* injur'd Hair!

But when to Mischief Mortals bend their Will, 125
How soon they find fit Instruments of Ill!
Just then, *Clarissa* drew with tempting Grace
A two-edg'd Weapon from her shining Case;
So Ladies in Romance assist their Knight,
Present the Spear, and arm him for the Fight. 130
He takes the Gift with rev'rence, and extends
The little Engine on his Fingers' Ends;
This just behind *Belinda's* Neck he spread
As o'er the fragrant Steams she bends her Head:
Swift to the Lock a thousand Sprights repair, 135

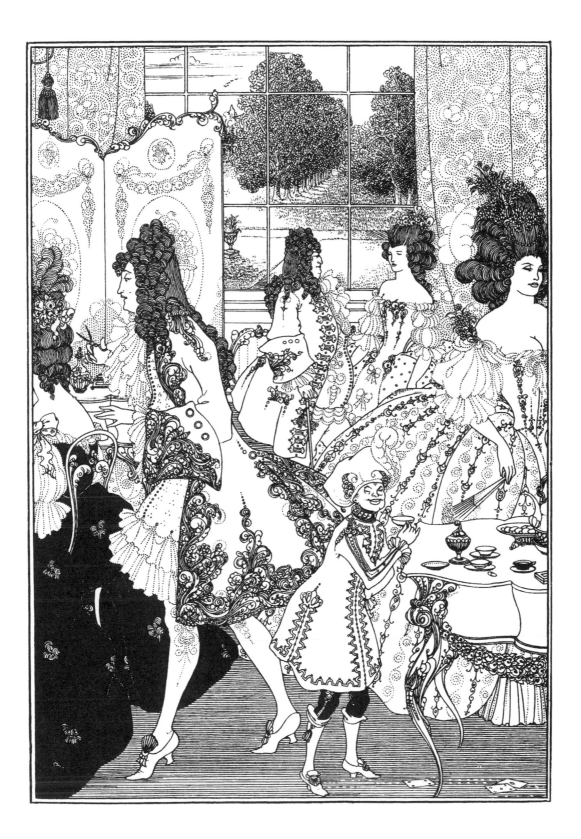

A thousand Wings, by turns, blow back the Hair;
And thrice they twitch'd the Diamond in her Ear,
Thrice she look'd back, and thrice the Foe drew near.
Just in that instant, anxious *Ariel* sought
The close Recesses of the Virgin's thought;　　　140
As on the Nosegay in her Breast reclin'd,
He watch'd th' Ideas rising in her Mind,
Sudden he view'd, in spite of all her Art,
An Earthly Lover lurking at her Heart.
Amaz'd, confus'd, he found his Power expir'd,　　　145
Resign'd to Fate, and with a Sigh retir'd.

　　The *Peer* now spreads the glittering *Forfex* wide,
T' inclose the Lock; now joins it, to divide.
Ev'n then, before the fatal Engine clos'd,
A wretched *Sylph* too fondly interpos'd;　　　150
Fate urged the Sheers, and cut the *Sylph* in twain,
(But Airy Substance soon unites again)
The meeting Points the sacred Hair dissever
From the fair Head, for ever and for ever!

　　Then flash'd the living Lightnings from her Eyes,　　　155
And Screams of Horror rend th' affrighted Skies.
Not louder Shrieks to pitying Heav'n are cast,
When Husbands, or when Lapdogs breath their last,

[handwritten margin notes:]
— reference to "Thousand ships" of Illiad & Odessey.

Ariel cannot stop Baron because Belinda wants to be "violated."

Or when rich *China* Vessels, fal'n from high,
In glitt'ring Dust and painted Fragments lie! 160

Let Wreaths of Triumph now my Temples twine,
(The Victor cry'd) the glorious Prize is mine!
While Fish in Streams, or Birds delight in Air,
Or in a Coach and Six the *British* Fair,
As long as *Atalantis* shall be read, 165
Or the small Pillow grace a Lady's Bed,
While *Visits* shall be paid on solemn Days,
When num'rous Wax-lights in bright Order blaze,
While Nymphs take Treats, or Assignations give,
So long my Honour, Name, and Praise shall live! 170

What Time would spare, from Steel receives its date,
And Monuments, like Men, submit to Fate!
Steel cou'd the Labour of the Gods destroy,
And strike to Dust th' Imperial Tow'rs of *Troy;*
Steel cou'd the Works of mortal Pride confound, 175
And hew Triumphal Arches to the Ground.
What Wonder then, fair Nymph! thy Hair shou'd feel
The conqu'ring Force of unresisted Steel?

CANTO IV

BUT anxious Cares the pensive Nymph oppress'd,
And secret Passions labour'd in her Breast.
Not youthful Kings in Battle seiz'd alive,
Not scornful Virgins who their Charms survive,
Not ardent Lovers robb'd of all their Bliss, 5
Not ancient Ladies when refus'd a Kiss,
Not Tyrants fierce that unrepenting die,
Not *Cynthia* when her *Manteau*'s pinn'd awry,
E'er felt such Rage, Resentment, and Despair,
As Thou, sad Virgin! for thy ravish'd Hair. 10

 For, that sad moment, when the *Sylphs* withdrew,
And *Ariel* weeping from *Belinda* flew,
Umbriel, a dusky, melancholy Sprite,
As ever sully'd the fair Face of Light,
Down to the Central Earth, his proper Scene, 15
Repair'd to search the gloomy Cave of *Spleen*.

 Swift on his sooty Pinions flits the *Gnome*,

And in a Vapour reach'd the dismal Dome.
No cheerful Breeze this sullen Region knows,
The dreaded *East* is all the Wind that blows. 20
Here in a Grotto, shelter'd close from Air,
And screen'd in Shades from Day's detested Glare,
She sighs for ever on her pensive Bed,
Pain at her Side, and *Megrim* at her Head.

 Two Handmaids wait the Throne : Alike in Place, 25
But diff'ring far in Figure and in Face.
Here stood *Ill-nature* like an *ancient Maid*,
Her wrinkled form in *Black* and *White* array'd ;
With store of Pray'rs, for Mornings, Nights, and Noons,
Her Hand is fill'd ; her Bosom with Lampoons. 30

 There *Affectation* with a sickly Mien,
Shows in her Cheek the Roses of Eighteen,
Practis'd to Lisp, and hang the Head aside,
Faints into Airs, and languishes with Pride ;
On the rich Quilt sinks with becoming Woe, 35
Wrapt in a Gown, for Sickness, and for Show.
The Fair ones feel such Maladies as these,
When each new Night-Dress gives a new Disease.

 A constant *Vapour* o'er the Palace flies ;
Strange Phantoms rising as the Mists arise ; 40

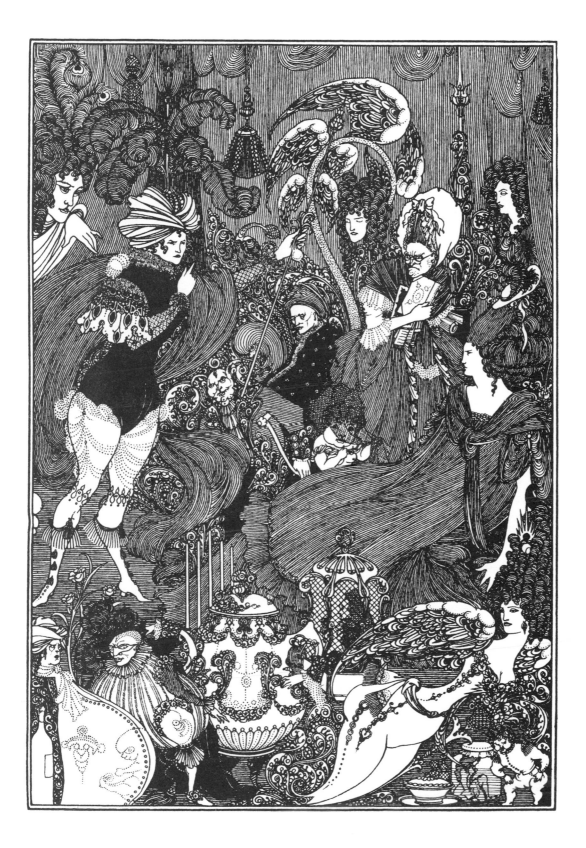

Dreadful, as Hermits' Dreams in haunted Shades,
Or bright, as Visions of expiring Maids.
Now glaring Fiends, and Snakes on rolling Spires,
Pale Spectres, gaping Tombs, and Purple Fires:
Now Lakes of liquid Gold, *Elysian* Scenes, 45
And Crystal Domes, and Angels in Machines.

 Unnumber'd Throngs, on ev'ry side are seen,
Of Bodies chang'd to various forms by *Spleen*.
Here living *Teapots* stand, one Arm held out,
One bent; the Handle this, and that the Spout: 50
A Pipkin there like *Homer's Tripod* walks;
Here sighs a Jar, and there a Goose-pye talks;
Men prove with Child, as pow'rful Fancy works,
And Maids turn'd Bottels, call aloud for Corks.

 Safe past the *Gnome* through this fantastic Band, 55
A Branch of healing *Spleenwort* in his Hand. — *like golden branch in Aeneid*
Then thus addrest the Pow'r—Hail wayward Queen;
Who rule the Sex to Fifty from Fifteen,
Parent of Vapors and of Female Wit,
Who give th' *Hysteric* or *Poetic* Fit, 60
On various Tempers act by various ways,
Make some take Physic, others scribble Plays;
Who cause the Proud their Visits to delay,
And send the Godly in a Pett, to pray.

A Nymph there is, that all thy Pow'r disdains,	65
And thousands more in equal Mirth maintains.
But oh! if e'er thy *Gnome* could spoil a Grace,
Or raise a Pimple on a beauteous Face,
Like Citron-Waters Matrons' Cheeks inflame,
Or change Complexions at a losing Game;	70
If e'er with airy Horns I planted Heads,
Or rumpled Petticoats, or tumbled Beds,
Or caus'd Suspicion when no Soul was rude,
Or discompos'd the Head-Dress of a Prude,
Or e'er to costive Lap-Dog gave Disease,	75
Which not the Tears of brightest Eyes could ease:
Hear me, and touch *Belinda* with Chagrin;
That single Act gives half the World the Spleen.

The Goddess with a discontented Air
Seems to reject him, tho' she grants his Pray'r.	80
A wond'rous Bag with both her Hands she binds,
Like that where once *Ulysses* held the Winds;
There she collects the Force of Female Lungs,
Sighs, Sobs, and Passions, and the War of Tongues.
A Vial next she fills with fainting Fears,	85
Soft Sorrows, melting Griefs, and flowing Tears.
The *Gnome* rejoycing bears her Gift away,
Spreads his black Wings, and slowly mounts to Day.

Sunk in *Thalestris'* Arms the Nymph he found,
Her Eyes dejected, and her Hair unbound. 90
Full o'er their Heads the swelling Bag he rent,
And all the Furies issu'd at the Vent.
Belinda burns with more than mortal Ire,
And fierce *Thalestris* fans the rising Fire.
O wretched Maid! she spread her Hands, and cry'd, 95
(While *Hampton's* Ecchoes, wretched Maid reply'd)
Was it for this you took such constant Care
The *Bodkin, Comb*, and *Essence* to prepare;
For this your Locks in Paper-Durance bound,
For this with tort'ring Irons wreath'd around! 100
For this with Fillets strain'd your tender Head,
And bravely bore the double Loads of Lead?
Gods! shall the Ravisher display your Hair,
While the Fops envy, and the Ladies stare!
Honour forbid! at whose unrivall'd Shrine 105
Ease, Pleasure, Virtue, All, our Sex resign.
Methinks already I your Tears survey,
Already hear the horrid Things they say,
Already see you a degraded Toast,
And all your Honour in a Whisper lost! 110
How shall I, then, your hapless Fame defend?
'Twill then be Infamy to seem your Friend!
And shall this Prize, th' inestimable Prize,

Expos'd through Crystal to the gazing Eyes,
And heighten'd by the Diamond's circling Rays, 115
On that Rapacious Hand for ever blaze?
Sooner shall Grass in *Hide-Park Circus* grow,
And Wits take Lodgings in the sound of *Bow;*
Sooner let Earth, Air, Sea, to *Chaos* fall,
Men, Monkeys, Lap-dogs, Parrots, perish all! 120

She said; then raging to Sir *Plume* repairs,
And bids her *Beau* demand the precious Hairs:
(Sir *Plume*, of *Amber Snuff-box* justly vain,
And the nice Conduct of a *Clouded Cane*)
With earnest Eyes and round unthinking Face, 125
He first the Snuff-box open'd, then the Case,
And thus broke out—" My Lord, why, what the Devil!
" Z——ds! damn the Lock! 'fore Gad, you must be civil!
" Plague on't! 'tis past a Jest—nay, prithee, Pox!
" Give her the Hair"—he spoke, and rapp'd his Box. 130

It grieves me much (replied the Peer again)
Who speaks so well shou'd ever speak in vain.
But by this Lock, this sacred Lock I swear,
(Which never more shall join its parted Hair;
Which never more its Honours shall renew, 135
Clipp'd from the lovely Head where late it grew)

That while my Nostrils draw the vital Air,
This Hand, which won it, shall for ever wear.
He spoke, and speaking, in proud Triumph spread
The long-contended Honours of her Head. 140

But *Umbriel*, hateful *Gnome!* forbears not so;
He breaks the Vial whence the Sorrows flow.
Then see! the Nymph in beauteous Grief appears,
Her Eyes half-languishing, half-drown'd in Tears;
On her heav'd Bosom hung her drooping Head, 145
Which, with a Sigh, she rais'd; and thus she said.

For ever curs'd be this detested Day,
Which snatch'd my best, my fav'rite Curl away!
Happy! ah ten times happy had I been,
If *Hampton-Court* these Eyes had never seen! 150
Yet am not I the first mistaken Maid,
By love of *Courts* to num'rous Ills betray'd.
Oh had I rather unadmir'd remain'd
In some lone Isle, or distant *Northern* land;
Where the gilt *Chariot* never mark'd the way, 155
Where none learn *Ombre*, none e'er taste *Bohea!*
There kept my Charms conceal'd from mortal Eye,
Like Roses that in Desarts bloom and die.
What mov'd my Mind with youthful Lords to rome?

O had I stay'd, and said my Pray'rs at home! 160
'Twas this the Morning *Omens* did foretel;
Thrice from my trembling Hand the *Patch-box* fell;
The tott'ring *China* shook without a Wind,
Nay, *Poll* sate mute, and *Shock* was most Unkind!
A *Sylph* too warn'd me of the Threats of Fate, 165
In mystic Visions, now believ'd too late!
See the poor Remnants of these slighted Hairs!
My Hands shall rend what ev'n thy Rapine spares.
These, in two sable Ringlets taught to break,
Once gave new Beauties to the snowy Neck. 170
The Sister-Lock now sits uncouth, alone,
And in its Fellow's Fate foresees its own;
Uncurl'd it hangs, the fatal Sheers demands;
And tempts once more thy sacrilegious Hands.
Oh hadst thou, Cruel! been content to seize 175
Hairs less in sight, or any Hairs but these!

CANTO V

SHE said: The pitying Audience melt in Tears,
But *Fate* and *Jove* had stopp'd the *Baron's* Ears.
In vain *Thalestris* with Reproach assails,
For who can move when fair *Belinda* fails?
Not half so fix'd the *Trojan* could remain, 5
While *Anna* begg'd and *Dido* rag'd in vain.
Then grave *Clarissa* graceful wav'd her Fan;
Silence ensu'd, and thus the Nymph began.

Say, why are Beauties prais'd and honour'd most,
The Wise Man's Passion, and the Vain Man's Toast? 10
Why deck'd with all that Land and Sea afford,
Why Angels call'd, and Angel-like ador'd?
Why round our Coaches crowd the white-gloved Beaux,
Why bows the Side-box from its inmost Rows?
How vain are all these Glories, all our Pains, 15
Unless good Sense preserve what Beauty gains:
That Men may say, when we the Front-box grace,

Behold the first in Virtue as in Face!
Oh! if to dance all Night, and dress all Day,
Charm'd the Small-pox, or chas'd old Age away; 20
Who would not scorn what Housewife's Cares produce,
Or who would learn one earthly Thing of Use?
To patch, nay ogle, might become a Saint,
Nor could it sure be such a Sin to paint.
But since, alas! frail Beauty must decay, 25
Curl'd or uncurl'd, since Locks will turn to grey;
Since painted, or not painted, all shall fade,
And she who scorns a Man, must die a Maid,
What then remains but well our Pow'r to use,
And keep good Humour still whate'er we lose? 30
And trust me, dear! good Humour can prevail,
When Airs, and Flights, and Screams, and Scolding fail.
Beauties in vain their pretty Eyes may roll;
Charms strike the Sight, but Merit wins the Soul.

So spoke the Dame, but no Applause ensu'd; 35
Belinda frown'd, *Thalestris* call'd her Prude.
To Arms, to Arms! the fierce Virago cries,
And swift as Lightning to the Combate flies.
All side in Parties, and begin th' Attack;
Fans clap, Silks rustle, and tough Whalebones crack; 40
Heroes and Heroins Shouts confus'dly rise,

And base, and treble Voices strike the Skies.
No common Weapons in their Hands are found,
Like Gods they fight, nor dread a mortal Wound.

So when bold *Homer* makes the Gods engage, 45
And heav'nly Breasts with human Passions rage ;
'Gainst *Pallas, Mars ; Latona, Hermes*, Arms ;
And all *Olympus* rings with loud Alarms.
Jove's Thunder roars, Heav'n trembles all around ;
Blue *Neptune* storms, the bellowing Deeps resound ; 50
Earth shakes her nodding Tow'rs, the Ground gives way,
And the pale Ghosts start at the Flash of Day !

Triumphant *Umbriel* on a Sconce's Height
Clapp'd his glad Wings, and sate to view the Fight,
Propp'd on their Bodkin Spears the Sprites survey 55
The growing Combat, or assist the Fray.

While through the Press enrag'd *Thalestris* flies,
And scatters Death around from both her Eyes,
A *Beau* and *Witling* perish'd in the Throng,
One dy'd in *Metaphor*, and one in *Song*. 60
O cruel Nymph ! a living death I bear,

Cried *Dapperwit*, and sunk beside his Chair.
A mournful Glance Sir *Fopling* upwards cast,
Those eyes are made so killing—was his last:
Thus on *Meander's* flow'ry Margin lies 65
Th' expiring Swan, and as he sings he dies.

As bold Sir *Plume* had drawn *Clarissa down*,
Chloe stepp'd in, and kill'd him with a Frown;
She smil'd to see the doughty Hero slain,
But at her Smile, the Beau reviv'd again. 70

Now *Jove* suspends his golden Scales in Air,
Weighs the Men's Wits against the Lady's Hair;
The doubtful Beam long nods from side to side;
At length the Wits mount up, the Hairs subside.

See fierce *Belinda* on the *Baron* flies, 75
With more than usual Lightning in her Eyes:
Nor fear'd the Chief th' unequal Fight to try,
Who sought no more than on his Foe to die.
But this bold Lord, with manly Strength endu'd,
She with one Finger and a Thumb subdu'd: 80
Just where the Breath of Life his Nostrils drew,

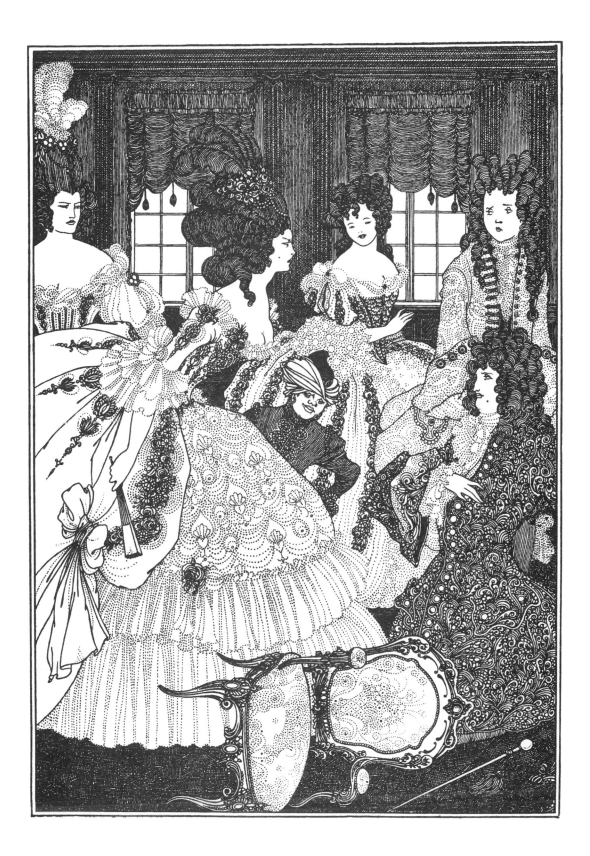

A charge of *Snuff* the wily Virgin threw;
The *Gnomes* direct, to ev'ry Atome just,
The pungent Grains of titillating Dust,
Sudden, with starting Tears each Eye o'erflows, 85
And the high Dome re-ecchoes to his Nose.

Now meet thy Fate, incens'd *Belinda* cry'd,
And drew a deadly *Bodkin* from her Side.
(The same, his ancient Personage to deck,
Her great great Grandsire wore about his Neck 90
In three *Seal-Rings;* which after melted down,
Form'd a vast *Buckle* for his Widow's Gown:
Her infant Grandame's *Whistle* next it grew,
The Bells she jingled, and the *Whistle* blew;
Then in a *Bodkin* grac'd her Mother's hairs, 95
Which long she wore, and now *Belinda* wears.)

Boast not my Fall (he cry'd) insulting Foe!
Thou by some other shalt be laid as low.
Nor think, to die dejects my lofty Mind.
All that I dread, is leaving you behind! 100
Rather than so, ah let me still survive,
And burn in *Cupid's* Flames—but burn alive.

Restore the Lock! she cries; and all around
Restore the Lock! the Vaulted Roofs rebound.
Not fierce *Othello* in so loud a Strain 105
Roar'd for the Handkerchief that caus'd his Pain.
But see how oft Ambitious Aims are cross'd,
And Chiefs contend 'till all the Prize is lost!
The Lock, obtain'd with Guilt, and kept with Pain,
In ev'ry place is sought, but sought in vain: 110
With such a Prize no Mortal must be blest,
So Heav'n decrees! with Heav'n who can contest?

Some thought it mounted to the Lunar Sphere,
Since all things lost on Earth, are treasur'd there.
There Heroe's Wits are kept in pond'rous Vases, 115
And Beau's in *Snuff-boxes* and *Tweezer-cases.*
There broken Vows, and Death-bed Alms are found,
And Lovers' Hearts with Ends of Riband bound;
The Courtier's Promises, and Sick Man's Pray'rs,
The Smiles of Harlots, and the Tears of Heirs, 120
Cages for Gnats, and Chains to Yoak a Flea;
Dried Butterflies, and Tomes of Casuistry.

But trust the Muse—she saw it upward rise,
Tho' marked by none but quick Poetic eyes:

Poet

(So *Rome's* great Founder to the Heav'ns withdrew, 125
To *Proculus* alone confess'd in view.)
A sudden Star, it shot through liquid Air,
And drew behind a radiant *Trail of Hair*.
Not *Berenice's* Locks first rose so bright,
The Skies bespangling with dishevel'd Light. 130
The *Sylphs* behold it kindling as it flies,
And pleas'd pursue its Progress through the Skies.

This the *Beau-monde* shall from the *Mall* survey,
And hail with *Musick* its propitious Ray.
This the blest Lover shall for *Venus* take, 135
And send up Vows from *Rosamonda's* Lake.
This *Partridge* soon shall view in cloudless Skies,
When next he looks through *Gallilæo's* Eyes;
And hence th' Egregious Wizard shall foredoom
The fate of *Louis*, and the fall of *Rome*. 140

Then cease, bright Nymph! to mourn the ravish'd Hair
Which adds new Glory to the shining Sphere!
Not all the Tresses that fair Head can boast
Shall draw such Envy as the Lock you lost.
For, after all the Murders of your Eye, 145
When, after Millions slain, yourself shall die;

When those fair Suns shall set, as set they must,
And all those Tresses shall be laid in dust;
This *Lock*, the Muse shall consecrate to fame,
And 'midst the stars inscribe *Belinda's* Name! 150

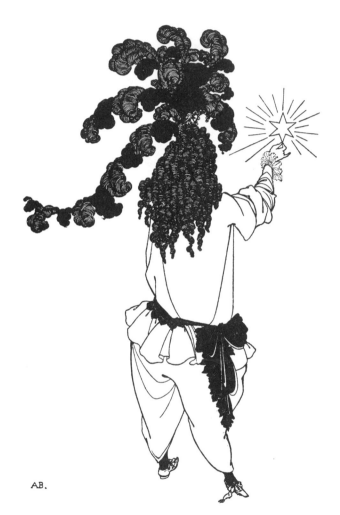

AB.

Notes

NOTES, INCLUDING THOSE BY THE AUTHOR

Nolueram, Belinda, tuos violare capillos ;
Sed juvat, hoc precibus me tribuisse tuis.—*Mart.*

IT appears by this motto that the following poem was written or published at the lady's request. But there are some further circumstances not unworthy relating. Mr. Caryl (a gentleman who was secretary to Queen Mary, wife of James II., whose fortunes he followed into France, author of the comedy of *Sir Solomon Single*, and of several translations in Dryden's miscellanies), originally proposed the subject to him, in a view of putting to an end, by this piece of ridicule, to a quarrel that was risen between two noble families, those of Lord Petre and of Mrs. Fermor, on the trifling occasion of his having cut a lock of her hair. The author sent it to the lady, with whom he was acquainted ; and she took it so well as to give about copies of it. That first sketch (we learn from one of his letters) was written in less than a fortnight, in 1711, in two Cantos only, and it was so printed ; first, in a miscellany of Bernard Lintott's, without the name of the author. But it was received so well, that he made it more considerable the next year by the addition of the machinery of the Sylphs, and extended it to five Cantos. We shall give the reader the pleasure of seeing in what manner these additions were inserted, so as to seem not to be added, but to grow out of the poem.

CANTO I

VER. 3. *Caryl*] In the first edition, C——l.

VER. 11-12. It was in the first Editions,

> And dwells such Rage in softest Bosoms then,
> And lodge such daring Souls in Little Men?—P.

VER. 13, etc. stood thus in the first Edition,

> Sol through white Curtains did his Beams display,
> And op'd those Eyes which brighter shine than they;
> *Shock* just had giv'n himself the rowzing Shake,
> And Nymphs prepared their *Chocolate* to take;
> Thrice the wrought Slipper knock'd against the Ground,
> And striking Watches the tenth Hour resound.—P.

VER. 19. *Belinda still, etc.*] All the Verses from hence to the End of the Canto were added afterwards.—P.

VER. 54-55. " Quae gratia currûm

> Armorumque fuit vivus, quae cura nitentes
> Pascere equos, eadem sequitur tellure repostos."

Virg. Æn. vi.—P.

VER. 108. *In the clear Mirror*] The Language of the Platonists, the Writers of the intelligible World of Spirits, etc.—P.

VER. 121. *And now unveil'd, etc.*] The Translation of these Verses, containing the Description of the Toilet, by our Author's Friend, Dr. Parnell, deserve, for their Humour, to be here inserted. —P.

> " Et nunc dilectum speculum, pro more retectum,
> Emicat in mensâ, quae splendet pyxidae densâ:
> Tum primum lymphâ se purgat candida Nympha,
> Jamque sine mendâ, cœlestis imago videnda,
> Nuda caput, bellos retinet, regit, implet ocellos.
> Hâc stupet explorans, ceu cultûs numen adorans.
> Inferior claram Pythonissa apparet ad aram,
> Fertque tibi cautè, dicatque superbia! lautè

Dona venusta ; oris, quae cunctis, plena laboris,
Excerpta explorat, dominamque deamque decorat.
Pyxide devotâ, se pandit hic India tota,
Et tota ex istâ transpirat Arabia cistâ.
Testudo hic flectit, dum se mea Lesbia pectit ;
Atque elephas lentè te pectit, Lesbia, dente ;
Hunc maculis nôris, nivei jacet ille coloris.
Hic jacet et mundè mundus muliebris abundè ;
Spinula resplendens aeris longo ordine pendens,
Pulvis suavis odore, et epistola suavis amore.
Induit arma ergo Veneris pulcherrima virgo,
Pulchrior in praesens tempus de tempore crescens :
Jam reparat risus, jam surgit gratia visûs,
Jam promit cultu miracula latentia vultu ;
Pigmina jam miscet, quo plus sua purpura gliscet,
Et geminans bellis splendet magè fulgor ocellis.
Stant Lemures muti, nymphae itentique saluti,
Hic figit zonam, capiti locat ille coronam,
Haec manicis formam, plicis dat et altera normam ;
Et tibi vel *Betty*, tibi vel nitidissima *Letty !*
Gloria factorum temerè conceditur horum."

VER. 145. *The busy Sylphs, etc.*] Ancient Traditions of the Rabbi's relate, that several of the fallen Angels became amorous of Women, and particularize some : among the rest Asael, who lay with Naamah, the wife of Noah, or of Ham ; and who, continuing impenitent, still presides over the women's Toilets.—Bereshi Rabbi in Genes. vi. 2.—P.

CANTO II

VER. 4. *Launch'd on the Bosom, etc.*] From hence the Poem continues, in the first Edition, to ver. 46,

The rest, the Winds dispers'd in empty Air ;

all after, to the End of the Canto, being additional.—P.

VER. 28. *With a single hair*] In allusion to those lines of *Hudibras*, applied to the same purpose,

> "And tho' it be a two foot Trout,
> 'Tis with a single hair pull'd out."—W.

VER. 38. In the Second Edition, here followed:

> There lay the Sword-knot *Sylvia's* hands had sown,
> With *Flavia's* Busk that oft had rapp'd his own:
> A Fan, a Garter, half a Pair of Gloves, etc.

VER. 45. *The Pow'rs gave Ear*] Virg. Æn. xi.—P.

VER. 90. *And guard with Arms*] The poet was too judicious to desire this should be understood as a compliment. He intended it for a mere piece of raillery; such as he more openly pursues on another occasion; when he says,

> "Where's now the Star which lighted Charles to rise?
> With that which followed Julius to the skies.
> Angels, that watch'd the Royal Oak so well,
> How chanc'd you slept when luckless Sorrel fell?"—W.

VER. 105. *Whether the nymph, etc.*] The disaster, which makes the subject of this poem, being a trifle, taken seriously; it naturally led the Poet into this fine satire on the female estimate of human mischances.

CANTO III

VER. 1. *Close by those Meads*] The First Edition continues from this Line to Ver. 24 of this Canto.—P.

VER. 11, 12. Originally in the First Edition,

> In various Talk the cheerful Hours they past,
> Of, who was bit, or who capotted last.—P.

VER. 24. *And the long Labours of the Toilet cease*] All that follows of the Game at Ombre, was added since the First Edition, till Ver. 105, which connected thus,

> Sudden the Board with Cups and Spoons is crown'd.—P.

VER. 105. *Sudden the Board*] From hence, the First Edition continues to Ver. 134.—P.

VER. 122. *And think of Scylla's Fate!*] Vide Ovid, Metam. viii.—P.

VER. 134. In the First Edition it was thus,

As o'er the fragrant Stream she bends her Head.—P.

VER. 147. First he expands the glitt'ring Forfex wide,
T' inclose the Lock ; then joins it to divide :
The meeting Points the sacred Hair dissever
From the fair Head, for ever, and for ever !

All that is between was added afterwards.—P.

VER. 157-8. In the earlier Editions,

Not louder Shrieks by Dames to Heav'n are cast
When Husbands, or when Monkeys, breath their last.

VER. 163, 170.

" Dum juga montis aper, fluvios dum piscis amabit,
Semper honos, nomenque tuum, laudesque manebunt." Virg.—P.

VER. 165. *Atalantis*] A famous book written about that time by a woman : full of Court and Party scandal ; and in a loose effeminacy of style and sentiment, which well suited the debauched taste of the better vulgar.—W.

Mrs. Manley, the author of it, was the daughter of Sir Roger Manley, Governor of Guernsey, and the author of the first volume of the famous *Turkish Spy*, published, from his papers, by Dr. Midgley. She was known and admired by all the wits of the times. She died in the house of Alderman Barber, Swift's friend ; and was said to have been the mistress of the alderman.

VER. 177. " Ille quoque eversus mons est, etc.
Quid faciant crines, cum ferro talia cedant ? "
Catull. de com. Berenices.

CANTO IV

VER. 1. "At regina gravi," etc. Virg. Aen. iv.

VER. 11. *For that sad Moment*] All the lines from hence to the 94th Verse, that describe the House of Spleen, are not in the First Edition ; instead, followed only these,

> While her rack'd Soul Repose and Peace requires,
> The fierce *Thalestris* fans the rising Fires.

And continued at the 94th Verse of this Canto.—P.

VER. 51. *Homer's Tripod walks*] See Hom. Iliad, xviii., of Vulcan's walking Tripods.—P.

VER. 52. *And there a Goose-pye talks*] Alludes to a real Fact, a Lady of Distinction imagined herself in this Condition.—P.

VER. 121. *Sir Plume repairs*] Sir George Brown. He was the only one of the Party who took the thing seriously. He was angry that the Poet should make him talk nothing but nonsense ; and in truth one could not well blame him.—W.

VER. 121. *But by this Lock*] In allusion to Achilles' Oath in Homer, Il. i.—P.

> VER. 141. But Umbriel, hateful *Gnome!* forbears not so ;
> He breaks the *Vial* whence the Sorrows flow.

These two Lines are additional ; and assign the Cause of the different Operation on the Passions of the two Ladies. The Poem went on before without that Distinction, as without any Machinery, to the end of the Canto.—P.

CANTO V

VER. 7. *Then grave Clarissa*] A new Character introduced into the subsequent Editions, to open more clearly the Moral of the Poem, in a Parody of the Speech of Sarpedon to Glaucus in Homer.—P.

VER. 7-37. These lines first occur in the 5th ed. of 1718.

VER. 35. *So spoke the Dame*] It is a Verse frequently repeated in Homer after any Speech.

 " So spoke——and all the heroes applauded."—P.

VER. 37. *To Arms, to Arms!*] From hence the First Edition goes on to the Conclusion, except a very few short Insertions added, to keep the Machinery in View to the End of the Poem.—P.

VER. 45. *So when bold Homer*] Homer, Il. xx.—P.

VER. 53. *Triumphant Umbriel*] These four Lines are added for the Reason before mentioned.

Minerva in like manner, during the Battle of Ulysses with the Suitors in the Odyss., perches on a Beam of the Roof to behold it.—P.

VER. 64. *Those Eyes are made so killing*] The words of a Song in the Opera of Camilla.—P.

VER. 65. *Thus on Meander's flow'ry Margin lies*]

 " Sic ubi fata vocant, udis abjectus in herbis,

 Ad vada Maeandri concinit albus olor." Ovid. Ep.—P.

VER. 71. *Now Jove*] Vide Homer, Il. viii., and Virg. Aen. xii.—P.

VER. 83. *The Gnomes direct*] These two Lines added for the same Reason.—P.

VER. 89. *The same, his ancient Personage to deck*] In Imitation of the Progress of Agamemnon's Sceptre in Homer, Il. ii.—P.

VER. 114. *Since all things lost*] Vide Ariosto, Canto xxxiv.—P.

VER. 128. " Flammiferumque trahens spatioso limite crinem

 Stella micat." Ovid.—P.

VER. 131. *The Sylphs behold*] These two Lines added for the same Reason, to keep in View the Machinery of the Poem.—P.

VER. 137. *This Partridge*] John Partridge was a ridiculous Star-gazer, who, in his Almanac, never failed to predict the Downfall of the Pope, and the King of France, then at War with the English.—P.